Through the Cracks

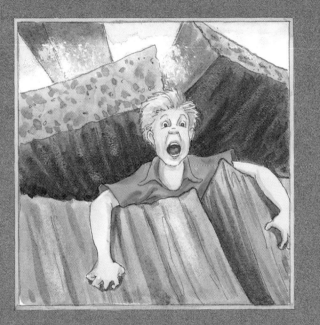

Story by Carolyn Sollman

Illustrations by Barbara Emmons Design by Judith Paolini

with creative assistance from Laurel Smith and Laura Sollman

Davis Publications, Inc. Artsake Publishing, Inc.

Acknowledgements

We wish to extend our appreciation to the following individuals whose faith, support and contributions of time, talent and expertise are helping to "close the cracks" in our nation's schools:

John, Jason and Joshua Sollman
Don Tarr
Jim Thibault

Edward Adams, James Baurley, Katy Baurley, Maggie Baurley, Marjorie Lake Baurley, Sarah Baurley, Kelli Bixler, Cindy Bixler Borgmann, JoAnn Brooks, Pat Browne, Lucy Bryant, Irene Buck, Deborah Burdick, Lisa Burk McCoy, Ed Buttwinick, Gilbert Clark, Cynthia Colbert, Ted Crawford, Willis Bing Davis, Stephen Dobbs, Franzee Dolbeare, Virgilyn Driscoll, Marcia Meulder Eaton, Harriet Mayor Fulbright, David Gamble, Harriet Gamble, Lynn Gardner, Robert Gehring, Joshua Glover, Ernest Goldstein, Derek Gordon, Jim Grant, Pamela Hudson, Gary Jones, Ronda King, Frances Kovacheff, Phyllis Kozlowski, Bob Long, Gay Gaer Luce, Duane Moore, Norihisa Nakase, Koya Ohashi, Jane Owen, Philip Pearlstein, Frank Philip, Thomas Pickering, Rosalind Ragans, Rick Rikhoff, Marcia Rieder, Carol Riggs, Dan Rushing, Sue Schenning Ryan, George Schricker, Neil Shulman, Shirley Smalley, Sarah Tambucci, Phyllis Land Usher, Joan Vaupen, Wyatt Wade, Carol Kelly Wessels, Frank Withrow, Barbara Wolf, Richard Wolf, James Wolfensohn, Bill Zeigler and Enid Zimmerman.

This story is dedicated to Bill Zeigler, my mentor, my friend.

Copyright ©1994 Carolyn Sollman
Davis Publications, Inc.
Worcester, Massachusetts U.S.A.

Design and Composition: Thibault Paolini Design Associates

Library of Congress Catalog Card Number: 93-74011
I S B N : 87192-293-2
10 9

Printed in U.S.A.

Welcome to a wonderful experience. *Through the Cracks* is a book that uses both written and visual language to address one of the major social issues of our society—the failure of formal organizations such as family, schools and churches to nurture and foster the growth and self-esteem of all our children. When children's needs are not met they mentally and emotionally withdraw thus failing to mature into productive adults. This book illustrates that by working together various organizations within a society can change the lives of all.

Through the eyes of the two lost children in the book, a person is able to see and sense the children's frustration and later, their exhilaration for learning. In an age where cutbacks are common in schools, often the art curricular offerings are reduced or eliminated. *Through the Cracks* demonstrates the need for children to experience learning through an integrated approach using more than one medium for communication.

Shirley F. Smalley
Superintendent of Schools
Marion, Indiana

Through the Cracks truly reflects the dilemma facing young people in many of today's educational institutions. If young people are not challenged to utilize all of their talents in the learning process and to participate in creative ways, they will surely "shrink" as well the hopes for the future of our country.

James D. Wolfensohn, Chairman
The John F. Kennedy Center for the Performing Arts
Washington, D.C.

June 1, 1993 Carolyn Sollman joined the Center for Arts in the Basic Curriculum (CABC) as Project Director for the "Close the Cracks" program. Ms. Sollman has written an imaginative book which speaks to both children and adults about the problem and has collaborated in the creation of videotapes on the benefits of the arts in education. Through these and other avenues she is working with CABC on a nationwide program to heighten public awareness about the poor condition of public school education in the United States and to work on solutions to this critical problem through integrating the arts in the curriculum.

The CABC is working to incorporate the arts as a fundamental element in primary and secondary education throughout the country. A significant part of each school day should be devoted to teaching the arts both as separate subjects for the benefits they impart in their own right and as integral elements of academic courses to enliven and reinforce the course work. The net result will be an improvement in the educational environment and standards in every elementary and secondary school in the country. The graduates of the future American high school will then be able to deal with the challenges of the 21st century in the workplace and at home as thoughtful responsible citizens.

Through the Cracks is the story, told with simplicity and truth, of a child who cannot find meaning or interest in schoolwork. I cannot imagine any reader, young or old, who will fail to understand the message and be moved by it.

If our schools are going to prepare thoughtful citizens who are life-long learners, they must heed the moral of Carolyn Sollman's beautifully told tale.

Harriet Mayor Fulbright, President
Center for Arts in the Basic Curriculum
Washington, D.C.

Hey, here I am…

Sorry, I'm a little out of breath after climbing that E but you were gonna turn the page and you didn't even see me and I'm the one who's supposed to tell you this story — oh, my name is Stella by the way — and it's a story that you gotta hear 'cause kids like you and kids like me — all these kids are shrinking, see, and I don't think anyone even notices! Oh well, anyway, now you can turn the page.

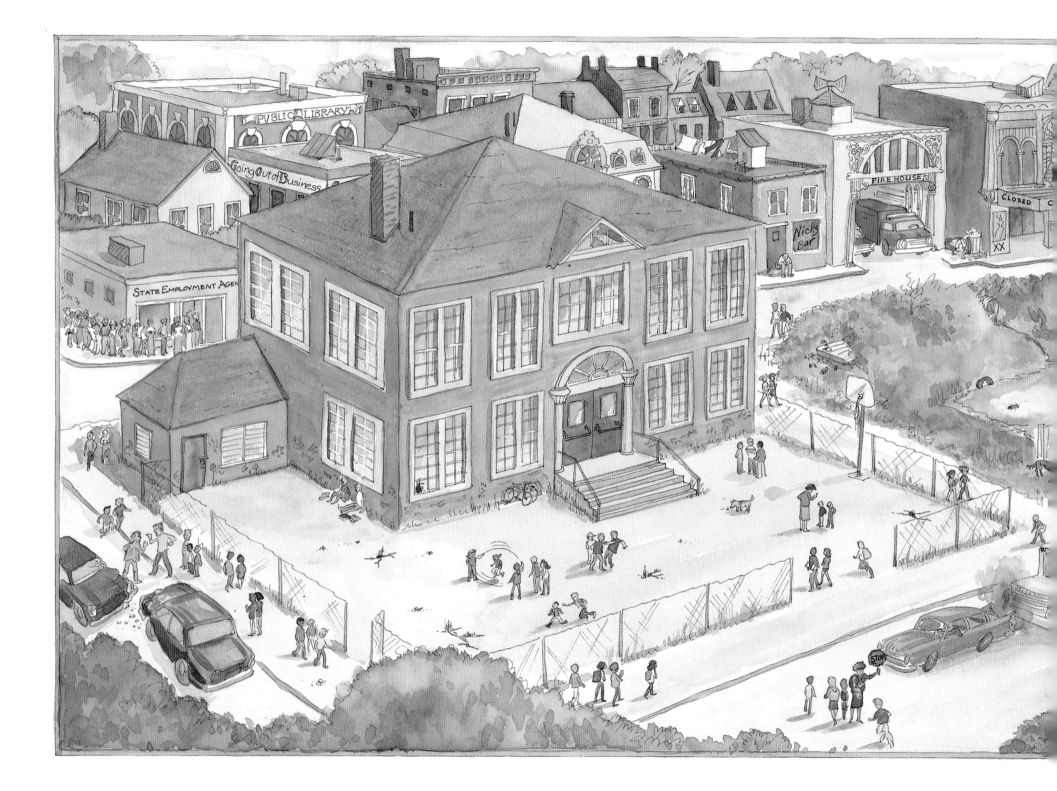

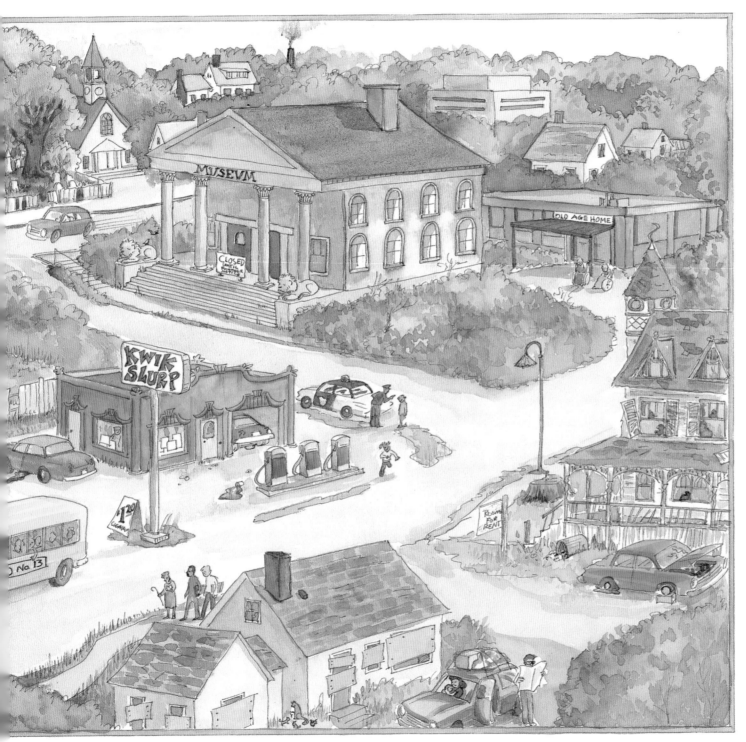

This is where I live.
It seems okay—but there's
a lot wrong here—look
closely or you'll miss
something just like you
almost missed me!

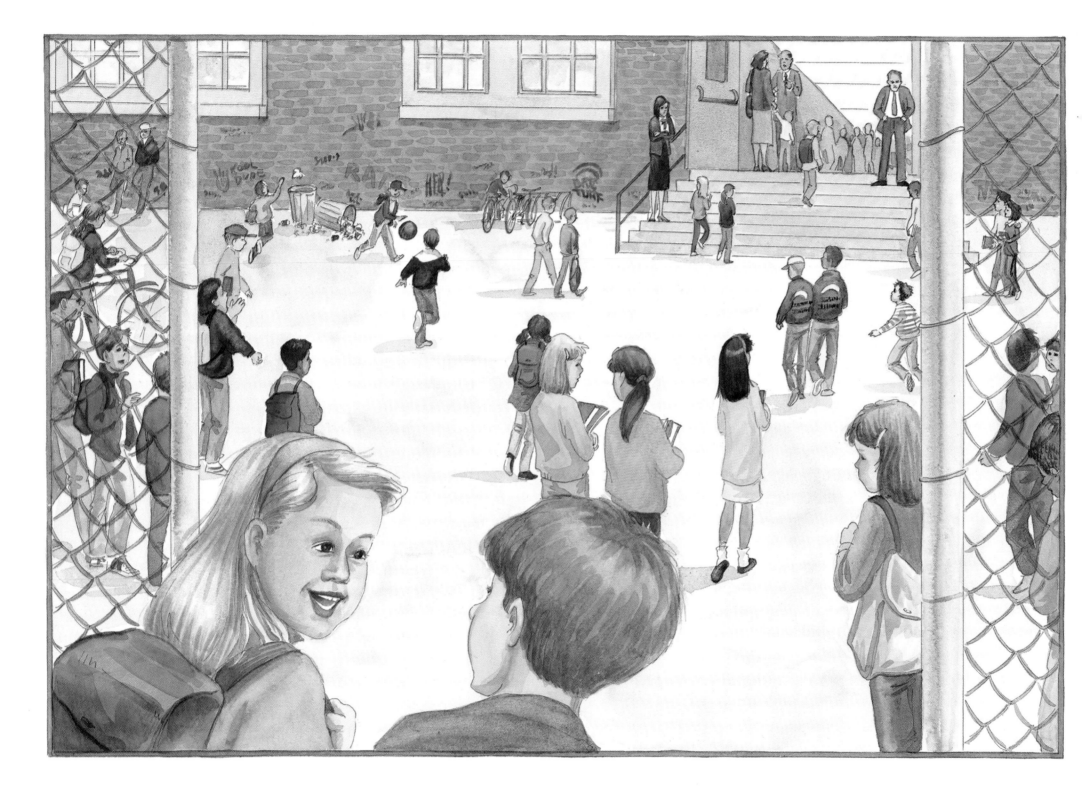

Here's my school. You know, I could hardly wait to go to school when I was little — well, uh, I mean little like when I was younger, not little like now that I've shrunk. I was *so* excited on my first day. I didn't need any alarm to wake me up. *No way.* I felt so big, and so important, and so full of wonderful ideas that I thought I would burst just like a balloon. School would be an adventure where I could do anything and everything!

But, something went wrong…

As you can see there are a lot of problems at my school. Some grown-ups say it's because kids just don't want to learn, but I know that's not true.

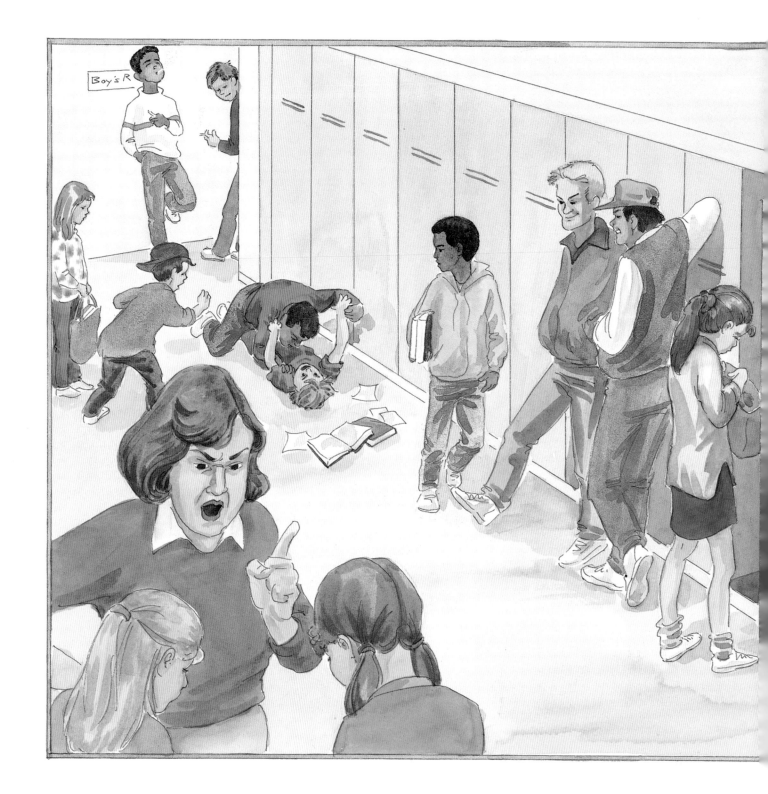

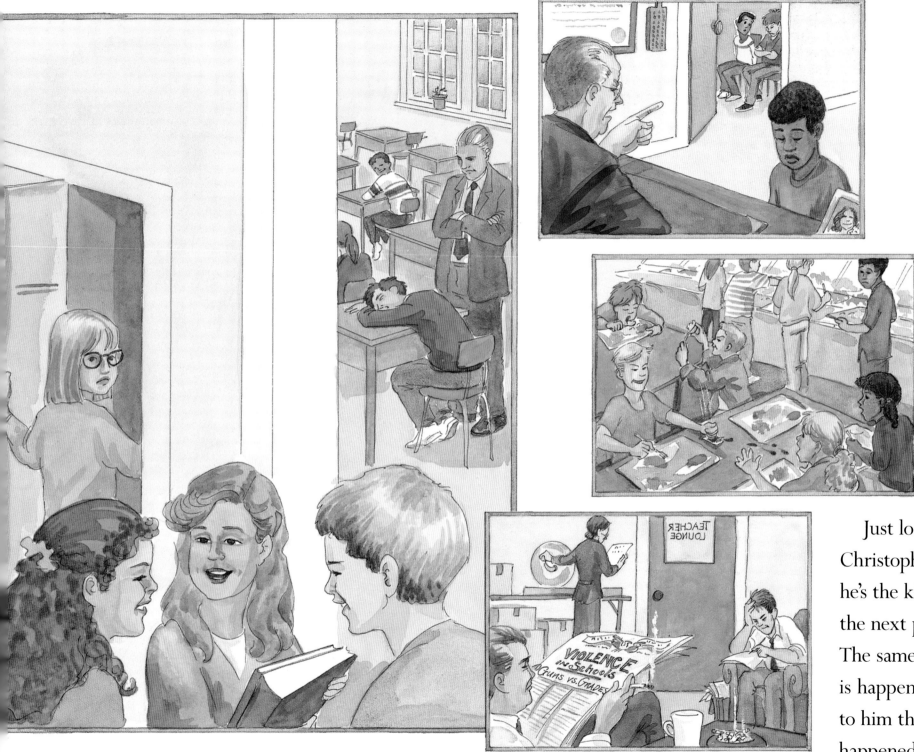

Just look at
Christopher—
he's the kid on
the next page.
The same thing
is happening
to him that
happened to me.

Christopher has been getting smaller every day. He sits at his desk and he watches his teacher write on the board. He watches the letters and numbers being written and erased. Boring, he thinks.

Boring,
Boring,
Boring.

Christopher doesn't think of anything except how boring everything is. He is so bored he doesn't even notice he's shrinking. You know, Christopher is really smart, but his grades aren't that great. Weird, huh? He's just shrunk too much and now he's about to fall right through the cracks of the schoolroom floor.

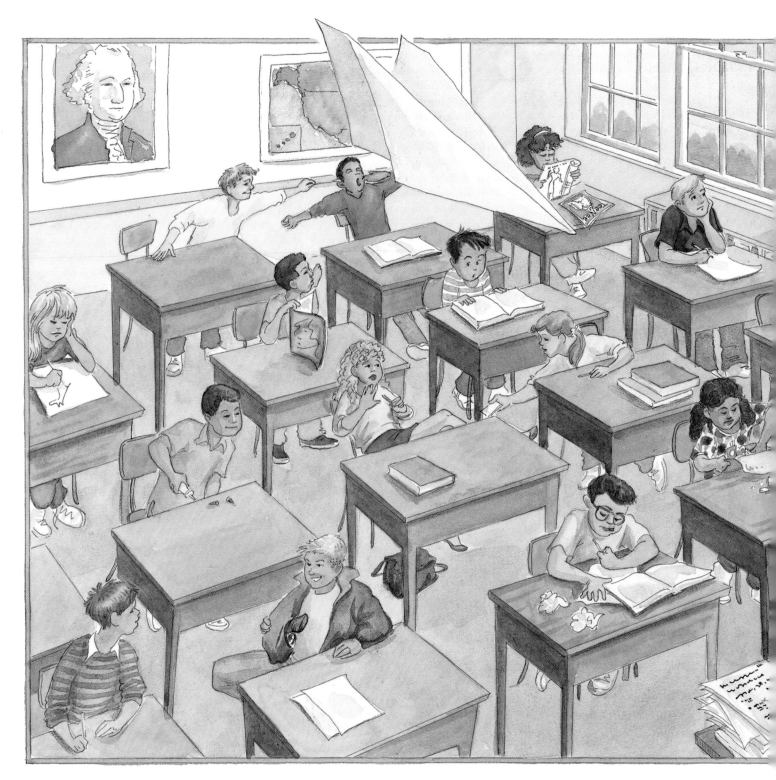

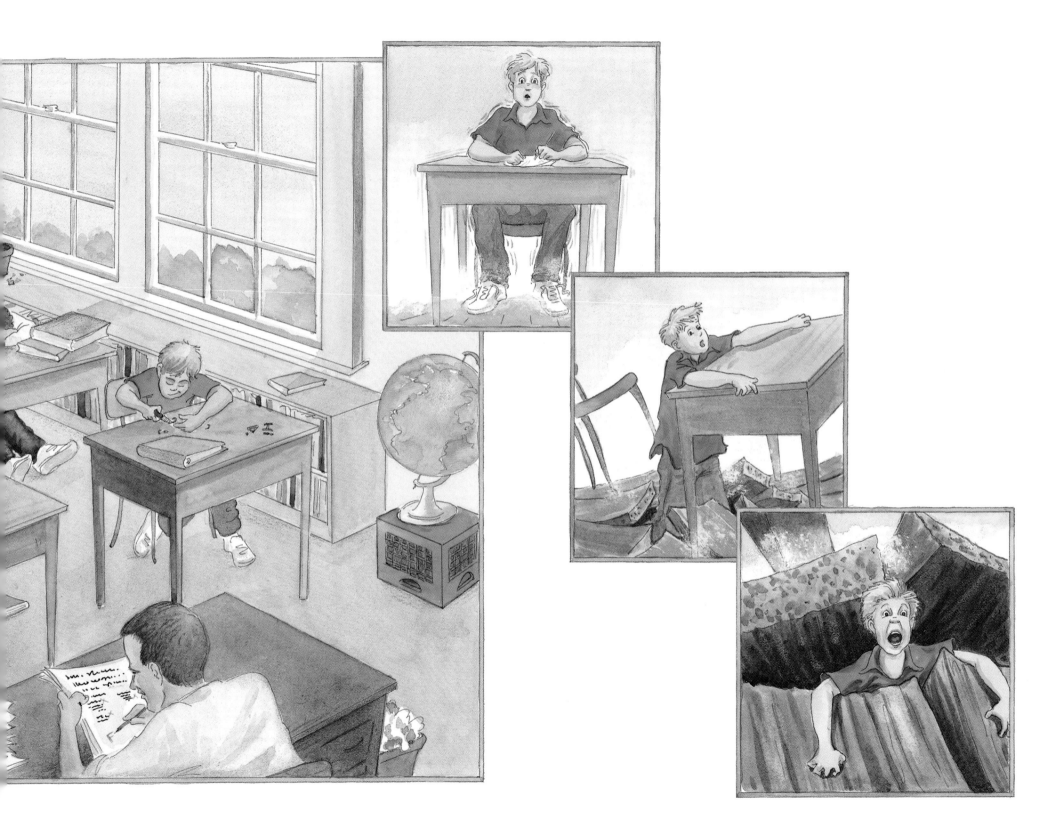

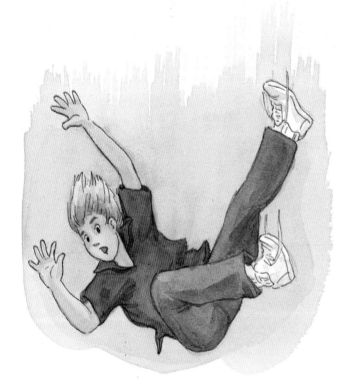

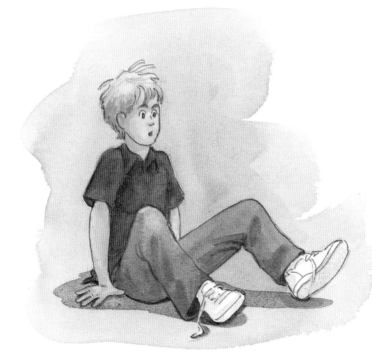

"Hi Christopher," I said. "You've fallen through the cracks."

Christopher was a little slow to answer. "Huh?" asked Christopher, "Do I know you? Did you say something?"

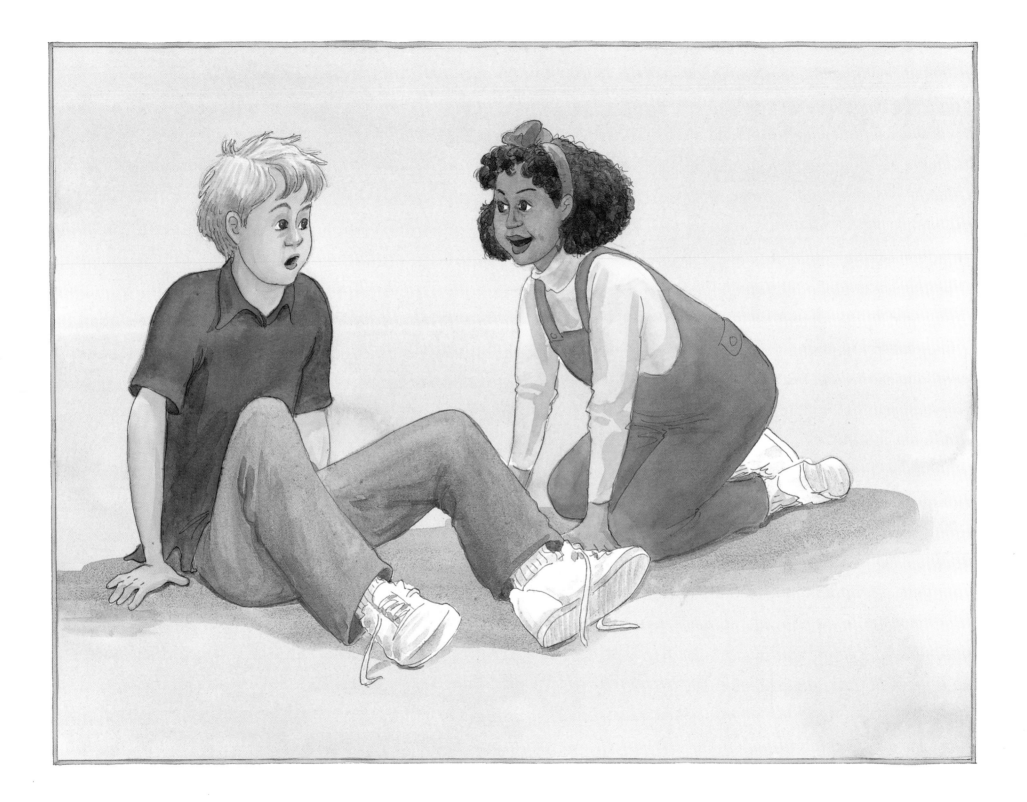

"Yes, I did say something," I replied. "I've watched your sneakers all morning—your shoestrings glow in the dark. You looked pretty bored in class, but now you're out of there. In answer to your other question, you know me now—I'm Stella."

I think he was trying to register my name in his memory when suddenly his eyes got big. "Wait a minute—I *am* out of class!" Christopher looked like he was about to scream with joy. "Awesome!"

"Yeah, it's awesome all right—but not like you're thinking." After all I've been here awhile. "Look around. Do you really want to be here?"

I sat back and watched
Christopher take in the place:
the gloomy walls, the silence
that made huge echoes of shouts
or crying, and the long dark
shadows—if they really were
just shadows. Falling through
the cracks felt creepy. And lonely.
The other kids down here keep
to themselves. That's why I made
up my mind to make Christopher
my friend before he got scared
or mean or quit talking like
the others.

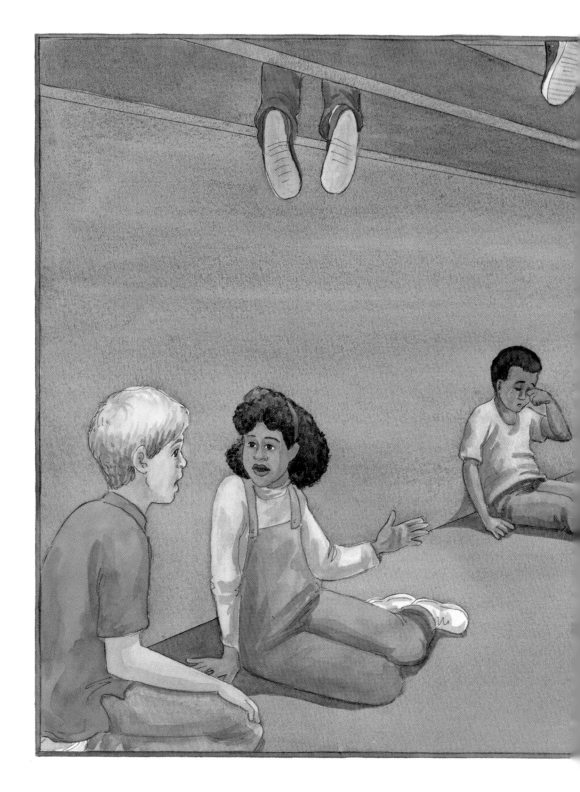

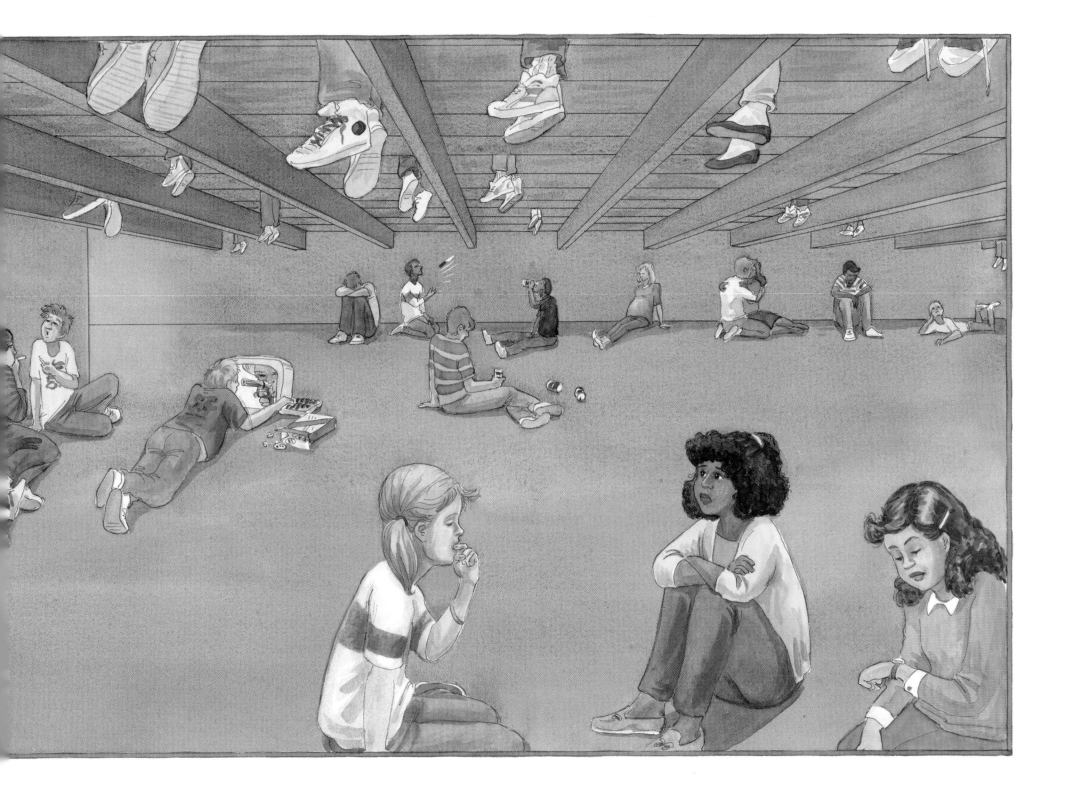

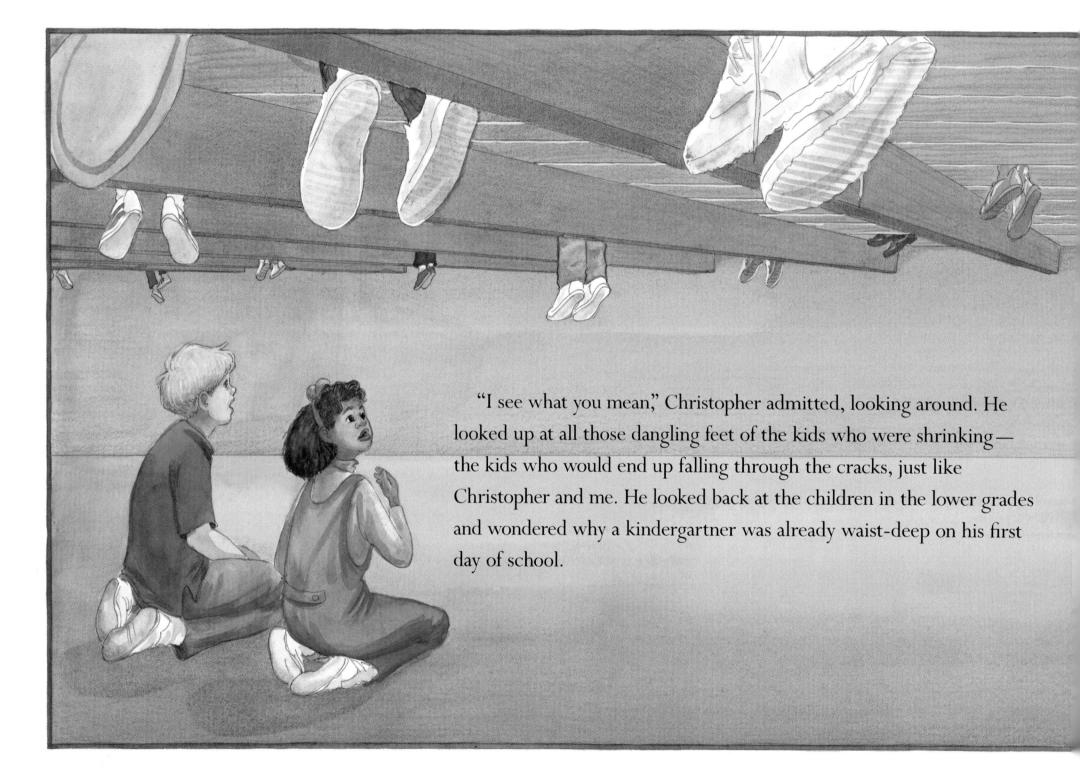

"I see what you mean," Christopher admitted, looking around. He looked up at all those dangling feet of the kids who were shrinking—the kids who would end up falling through the cracks, just like Christopher and me. He looked back at the children in the lower grades and wondered why a kindergartner was already waist-deep on his first day of school.

He looked ahead at the children in the upper grades and noticed that even some of the 'smart' kids were beginning to slip through. He looked at all the kids who had already fallen. Then he looked at me. "This place has some problems," he said. "But going back where I just came from isn't the answer either."

"Look," I began, "I've been here for a long time. I know what it's like here and I also know that school doesn't have to be boring." Christopher looked doubtful at that point. "I mean it. I think if we're willing to do a little exploring, we could find that there's more to school than sitting still and listening to a teacher go on and on."

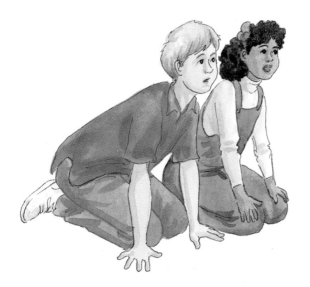

"Maybe," said Christopher as he thought it over. "Hey, why haven't you explored before now?"

I knew he would ask that. I was afraid to tell him. I thought he might laugh at me, but I had to be honest. "I don't like being in the dark alone. And I don't know where exploring will lead us."

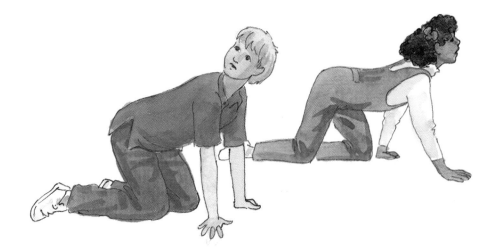

Christopher was quiet as he thought it over.
He looked around again.
Finally he looked over at me and said, "I don't like shrinking or being bored. Let's explore."

It wouldn't be easy, but making a friend helped. I couldn't be sure, but I thought Christopher and I were beginning—slowly—to grow.

As we moved along it was dark, but in the distance we could see the faintest of lights. There were noises, too: voices, but we couldn't quite make out the words, and laughter that made us feel sad instead of happy. I almost stopped right then and there. I think Christopher was afraid too, but we had to keep going. We crawled toward the nearest light. You know, I expected it to get brighter as we got closer, but it didn't.

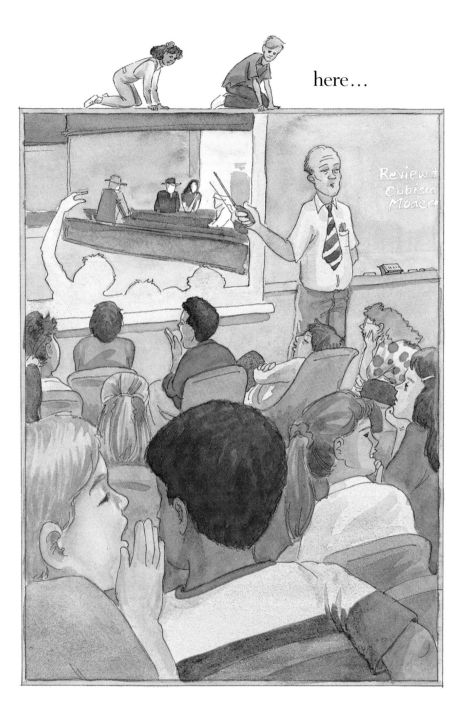

here…

It was a window covered with dirt and cobwebs. "Gross!" said Christopher as he tried to wipe a spot clean enough to see through. Christopher squeezed himself against one side so that I could see, too. We were outside of a classroom and we didn't like what we saw…

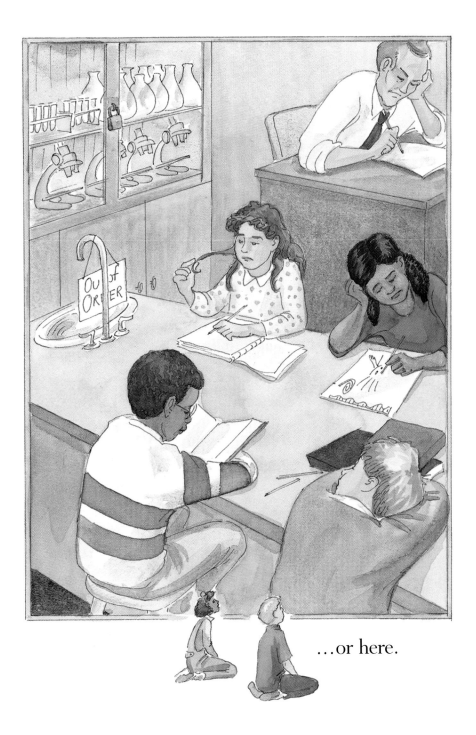

...or here.

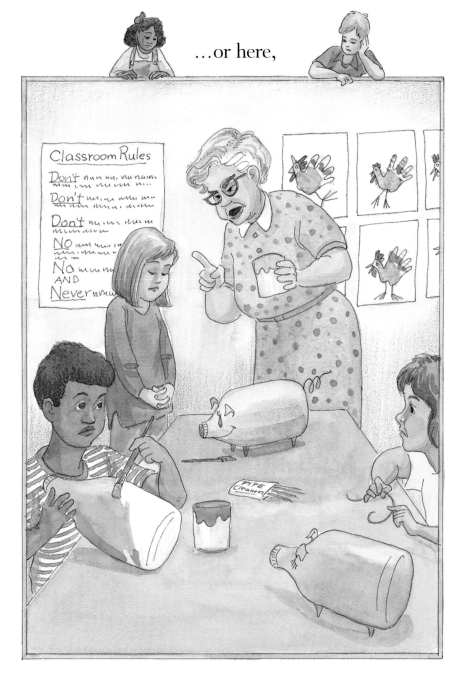

...or here,

We looked in other windows where more students were shrinking and the teachers weren't having much fun either.

"Christopher," I said once as we watched a group of students all staring at one blackboard, "Does this remind you of anything?"

"I don't think so, why?" Christopher asked.

"Because it reminds me of television. All those kids are just watching—no one is doing anything." I always liked to watch TV, but this was too much. "Just watching—even TV—is pretty boring."

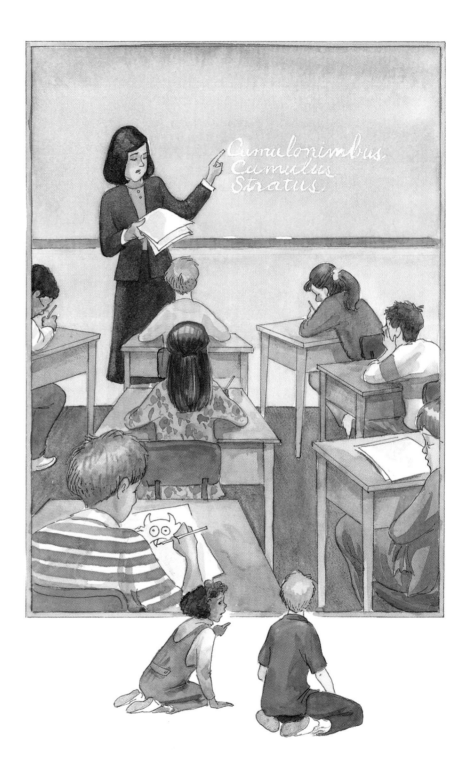

Christopher smiled at me, "I think we
are growing, Stella."

"I think you're right, Christopher."

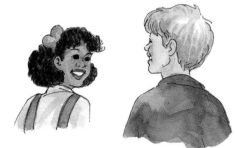

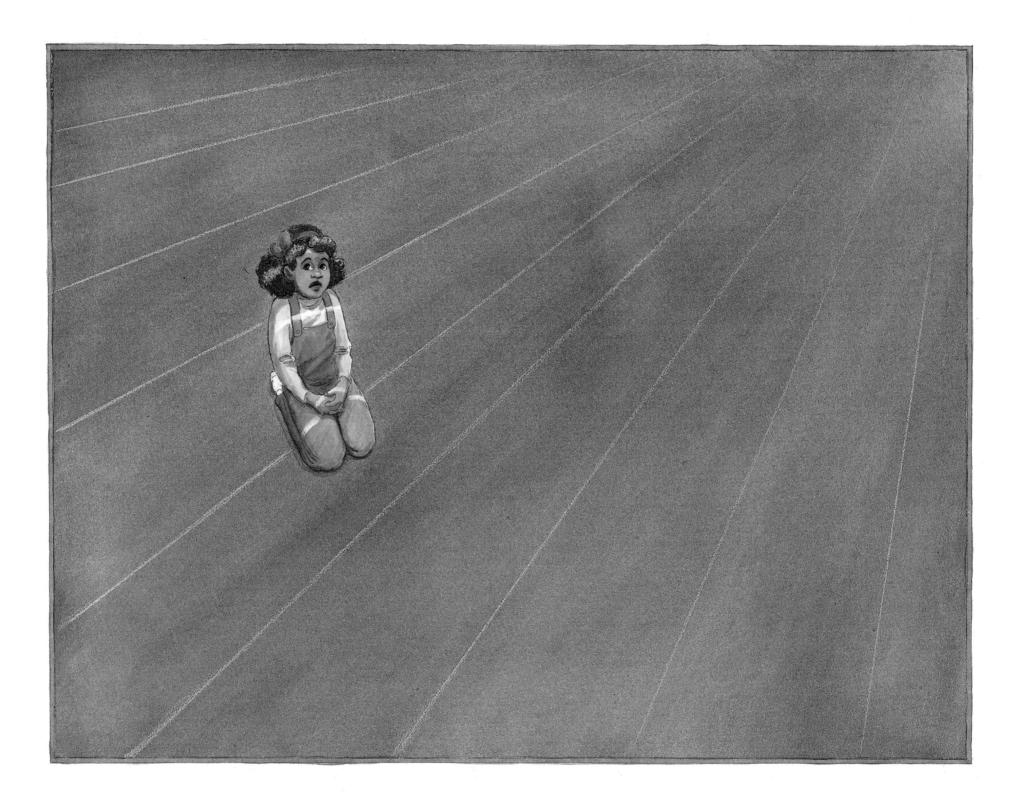

We were growing, too.
When I first fell through
the cracks, I thought the
noises in the distance
might be monsters. And I
thought the lights beyond
the shadows were raging
fires. In other words, I
thought the worst.

But I was wrong.
The monsters were fear and silence.

The distant noises weren't so scary when we got closer. They were voices—students and teachers talking and planning together.

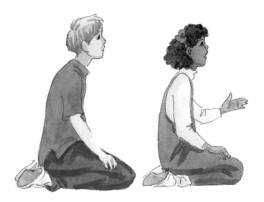

We weren't used to so much talk in the classroom; not talk behind the teacher's back, but kids talking about their work, and sharing ideas.

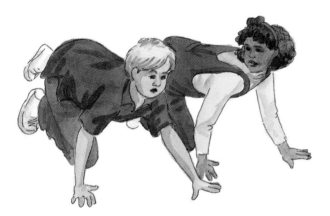

Christopher and I began to seek out the brightest and loudest windows. A good thing, too — we weren't so small anymore and the brighter rooms had the biggest windows!

Sometimes we couldn't believe it was school.

"Stella, look at that class!" Christopher pointed through a window. And it *was* amazing.

I thought at first that it was art. Then I didn't know what to think. "What class is this?" I asked Christopher.

"You know, I think it's history," he said. "But I never thought it could look like so much fun."

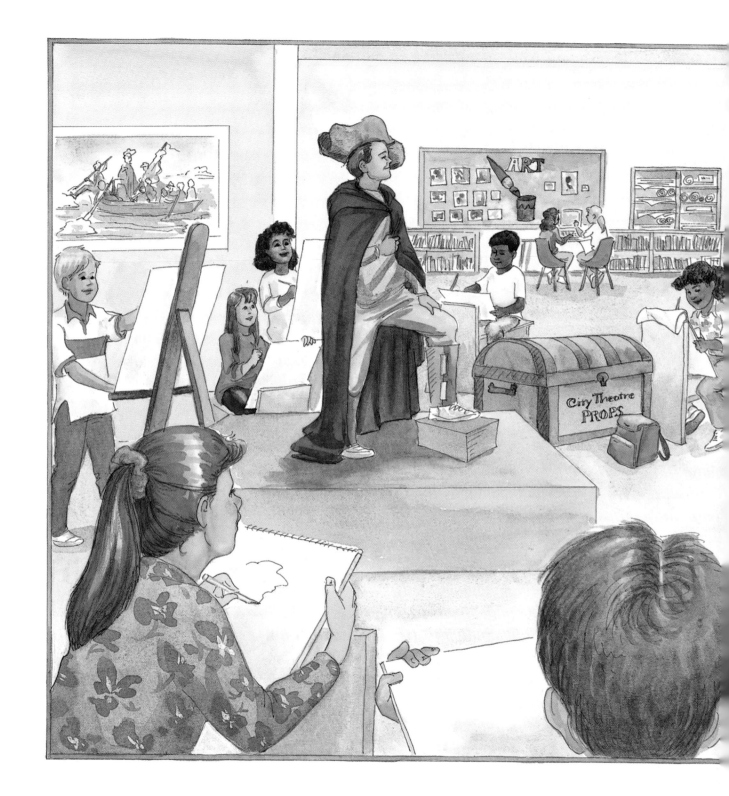

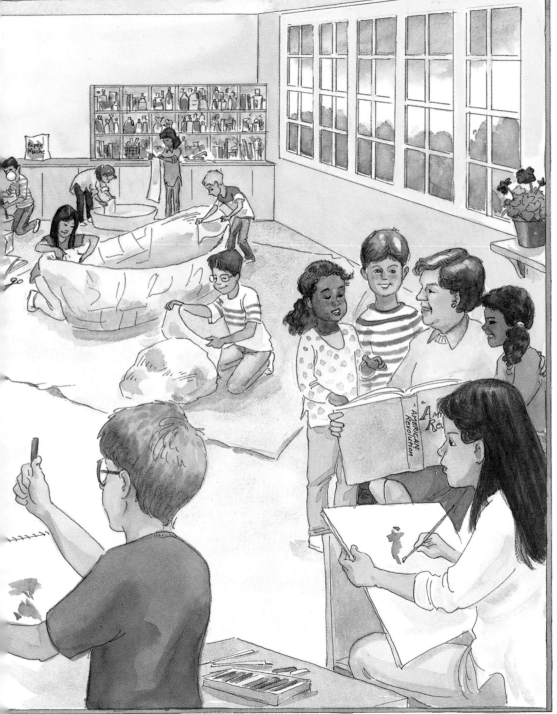
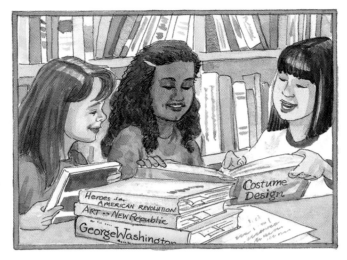
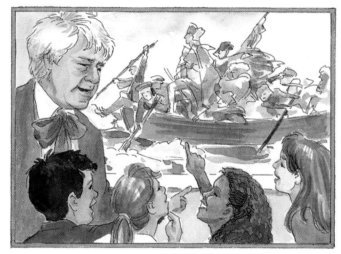
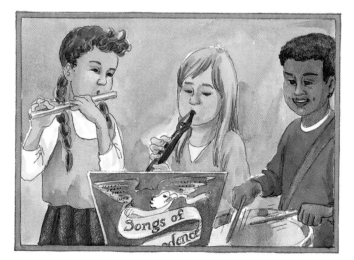

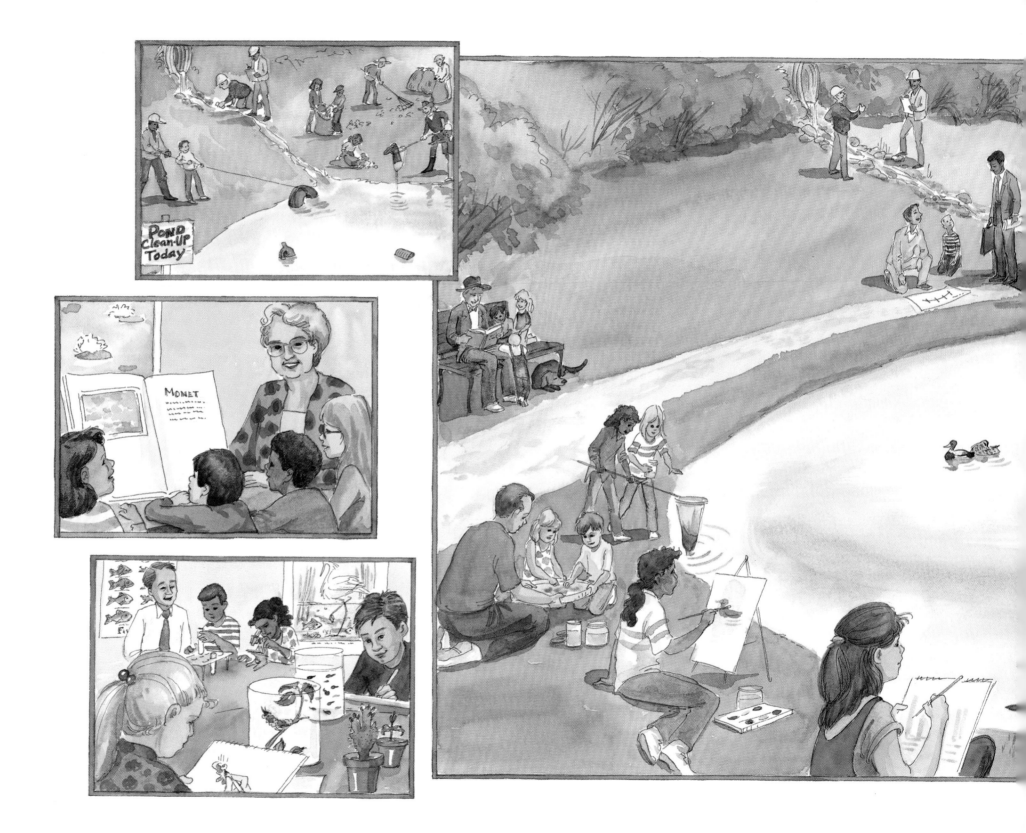

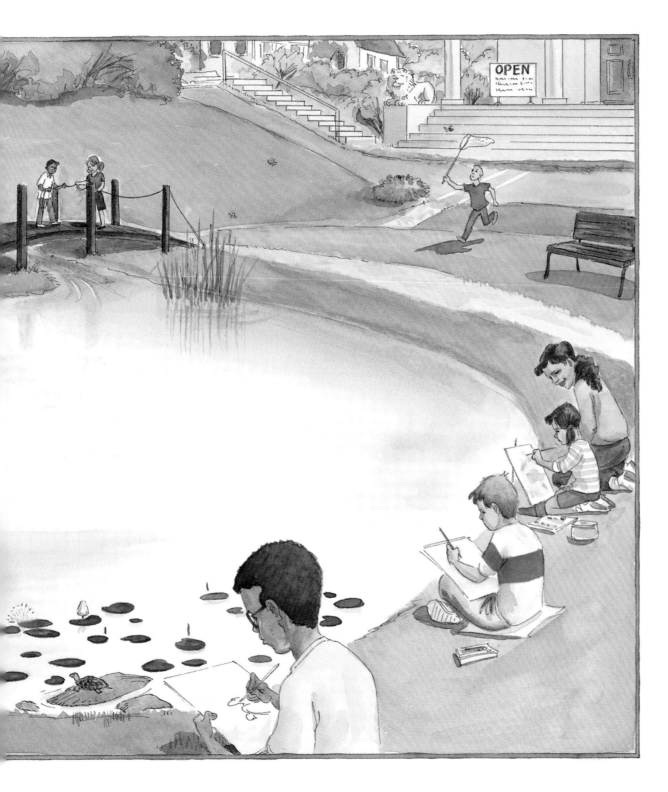

That wasn't the only one. "What class is this?" asked Christopher.

"Christopher, come over here— they're dancing!" I had wandered to another window, another class, and we still couldn't believe it.

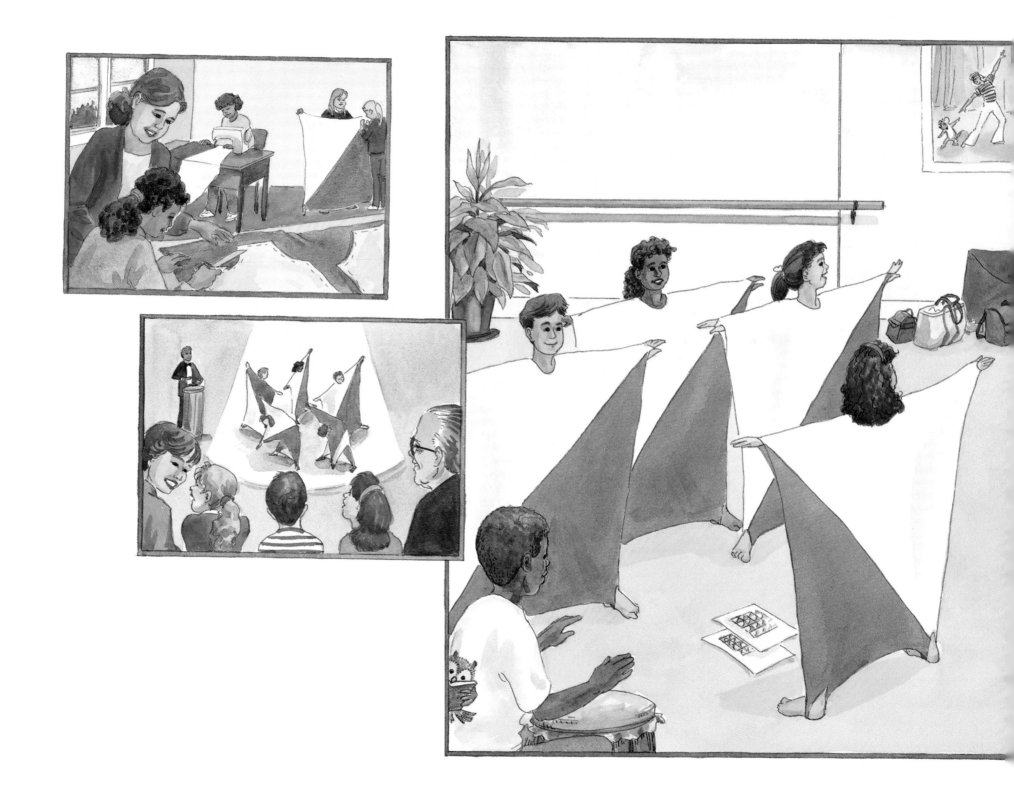

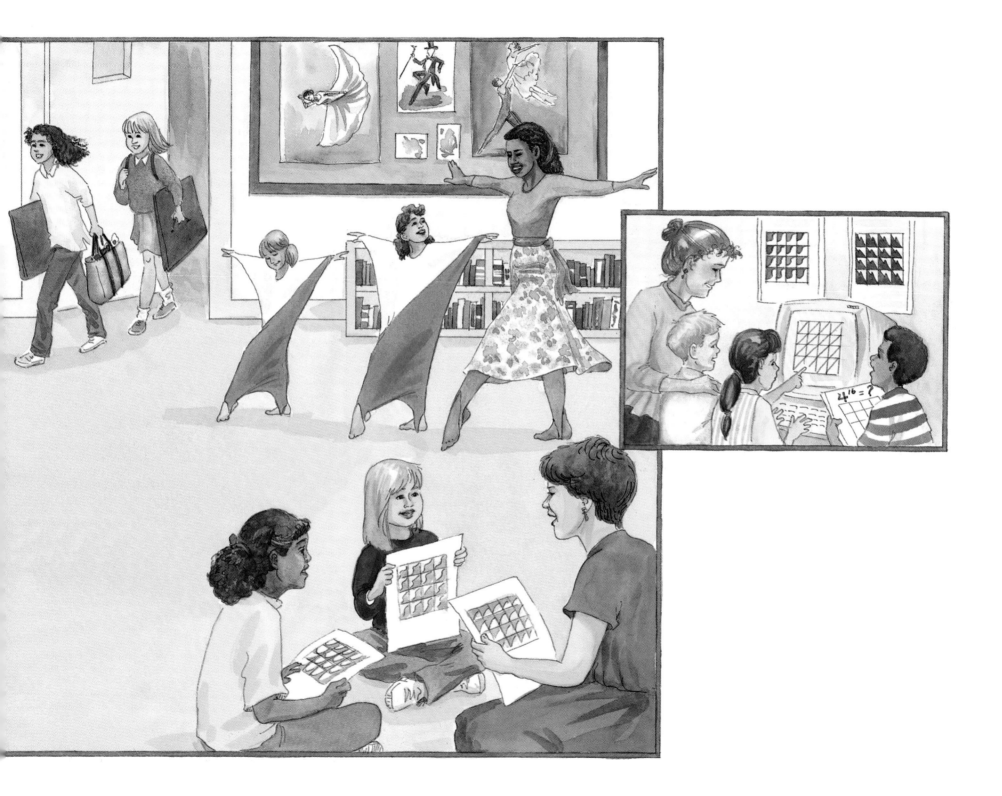

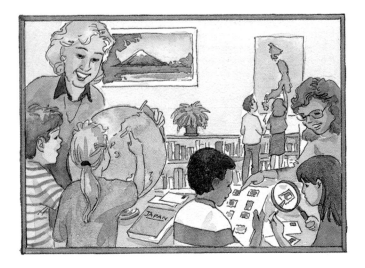

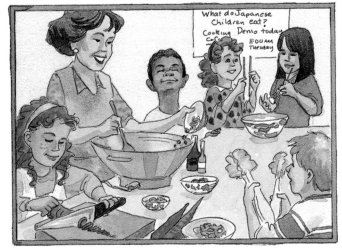

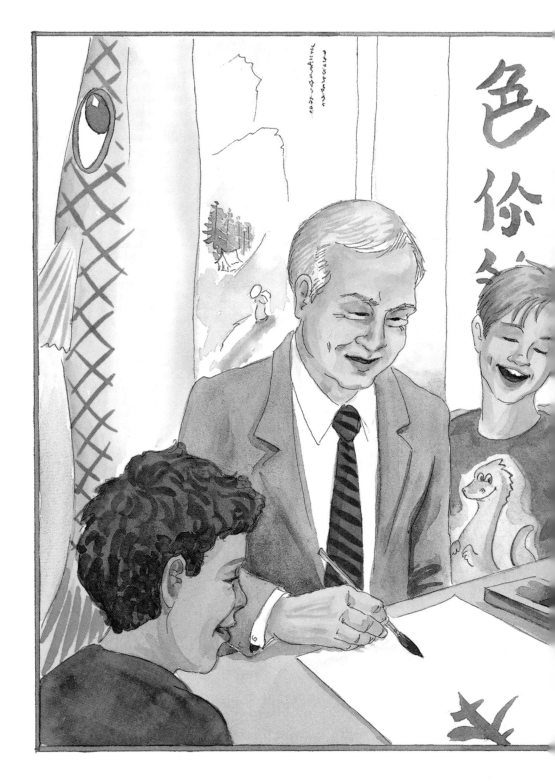

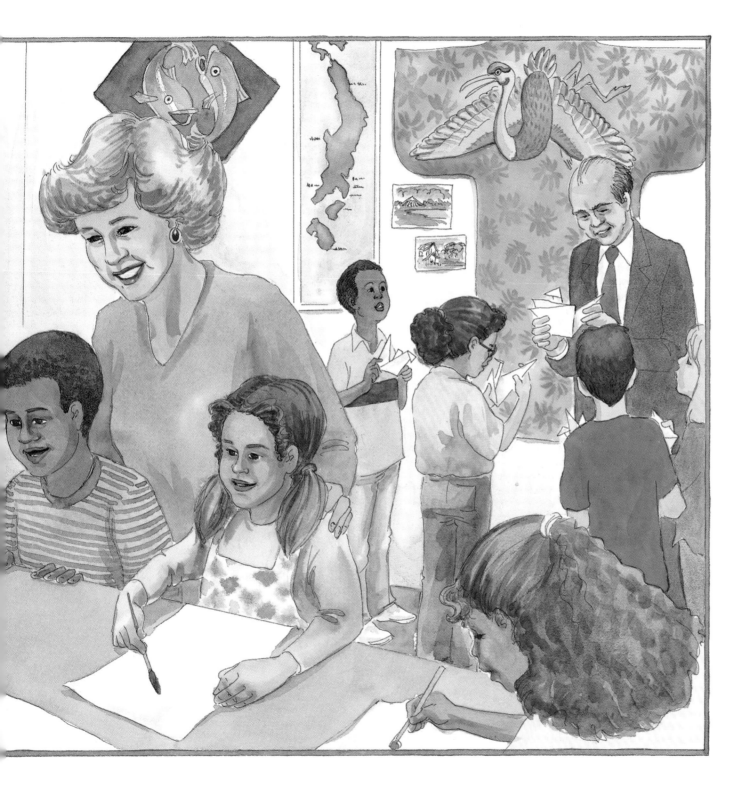

"I never thought I'd say this, but school isn't boring after all," Christopher was shaking his head as he spoke.

"If I were in there, I'm not sure what I'd do first."

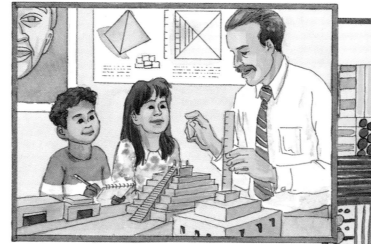
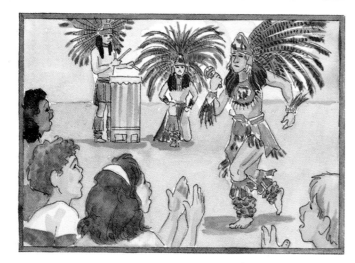
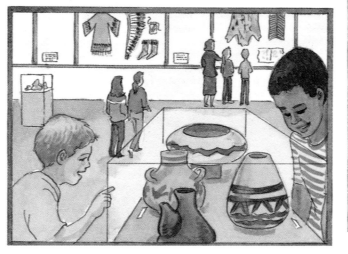
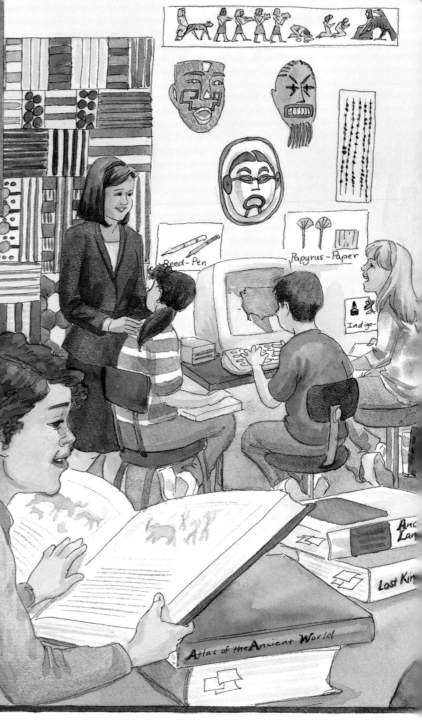

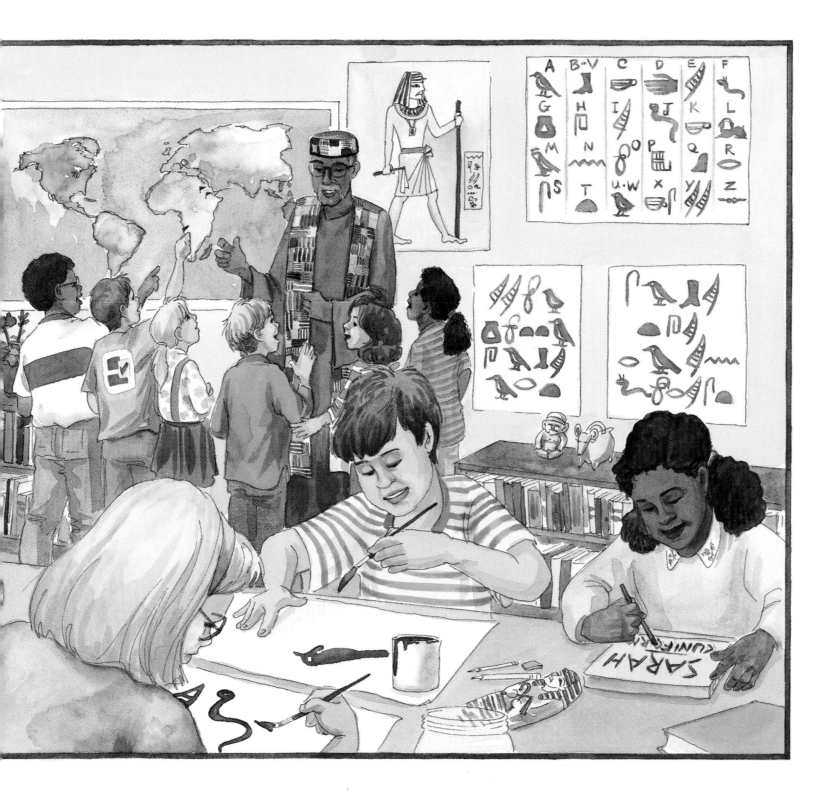

"Christopher, I don't see a single shrinking student over here," I was looking in the English class at this point.

"No kidding?" he asked as he hurried over.

"No kidding."

It seemed we saw millions of ways to do things, to learn things. We saw all kinds of possibilities and all kinds of people with new and exciting ideas. Everyone was working together. Some people were good with numbers, others were good with words, and still others were good with pictures.

"Hey, Stella, something is happening!" Christopher was right—the light was getting brighter and I felt—different.

"I think we're growing, Christopher!"

"I think you're right, Stella!"

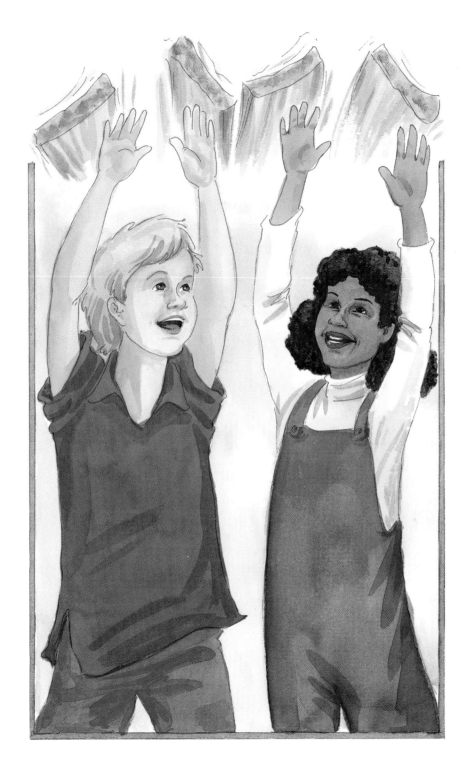

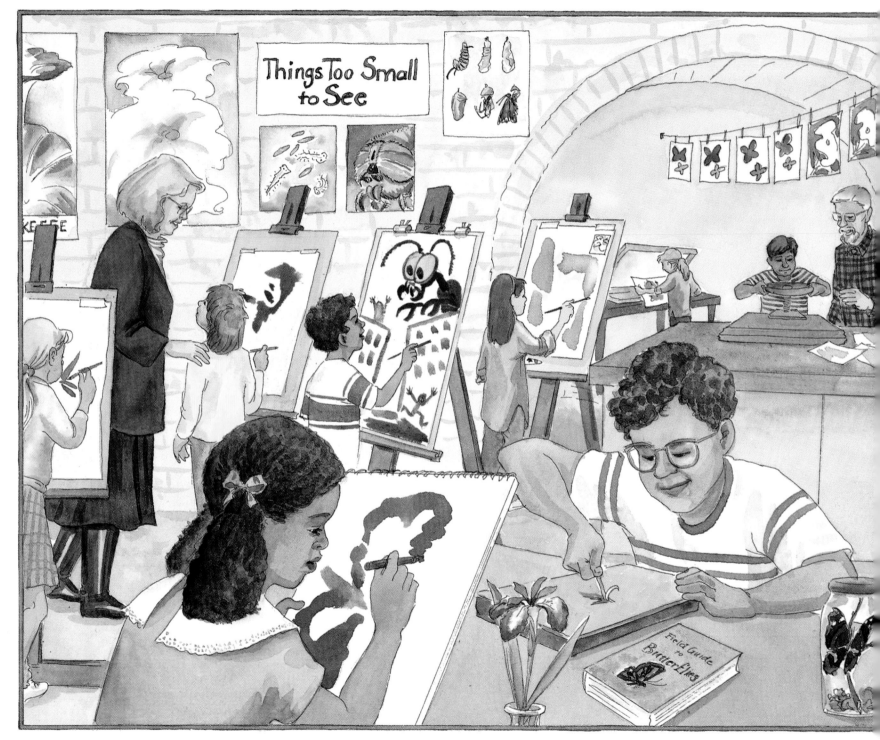

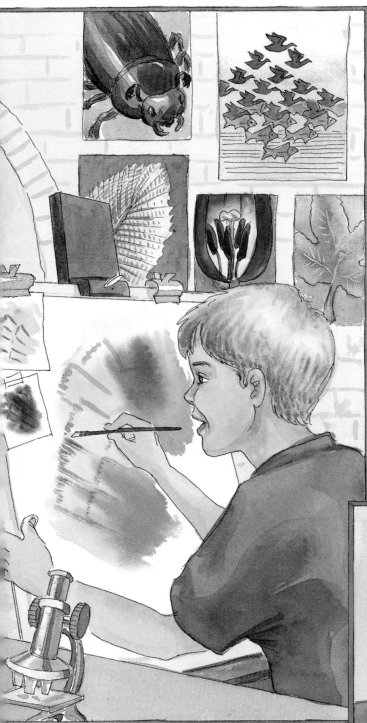

And it was true. Christopher and I found a way out of the darkness. We were no longer on the outside looking in. Christopher saw himself drawing and looking through a microscope and he was back.

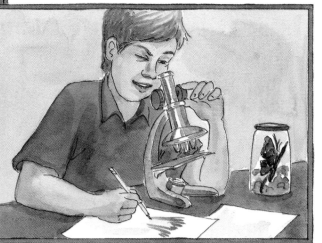

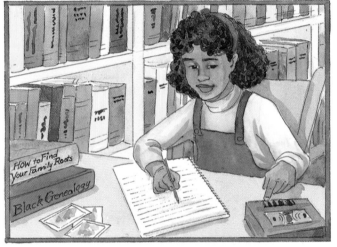

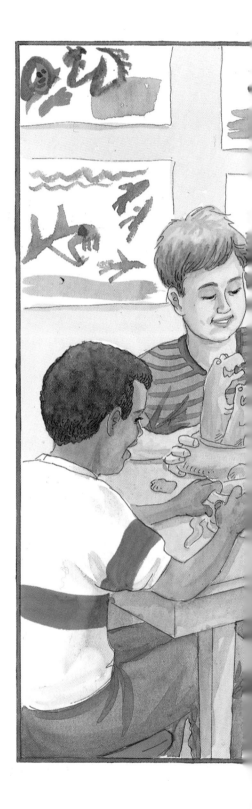

And me?
I taped an
interview with
my grandfather
and was writing
a historical
narrative. I was
back, too.

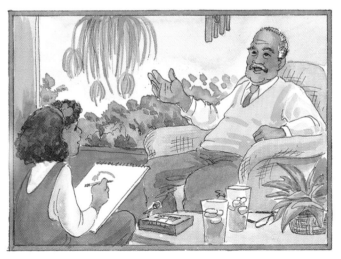

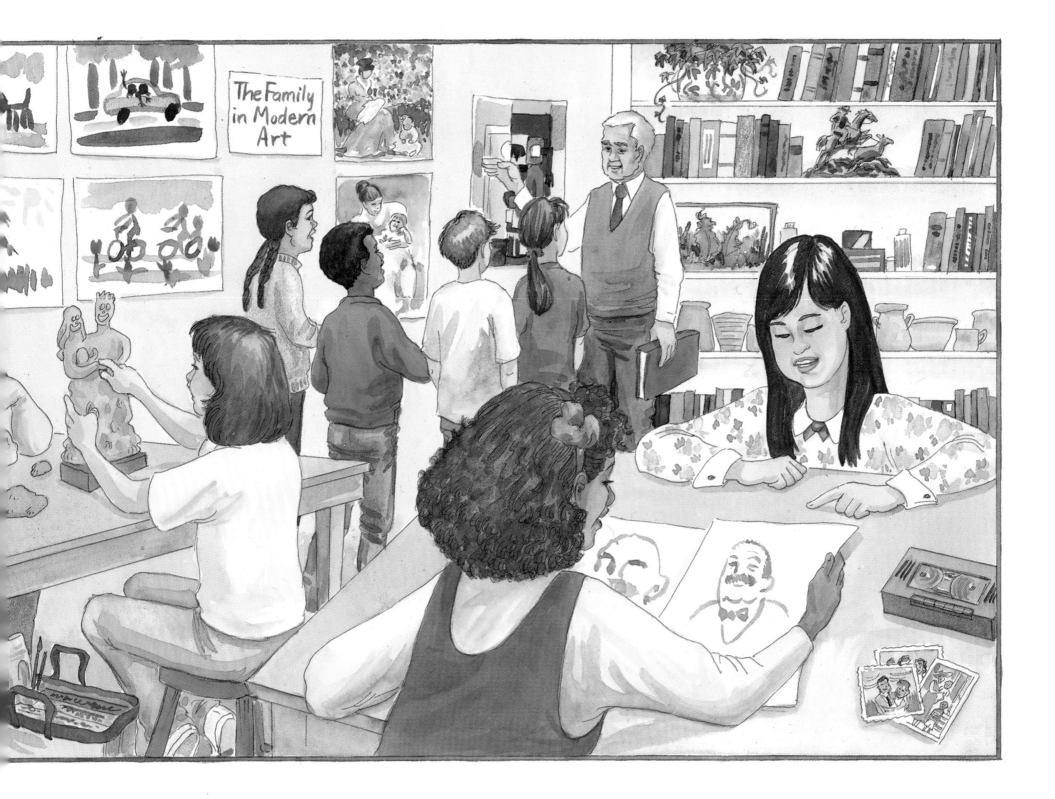

I like school now and so does Christopher.
We're not just watchers anymore and we're
thinking—not shrinking!

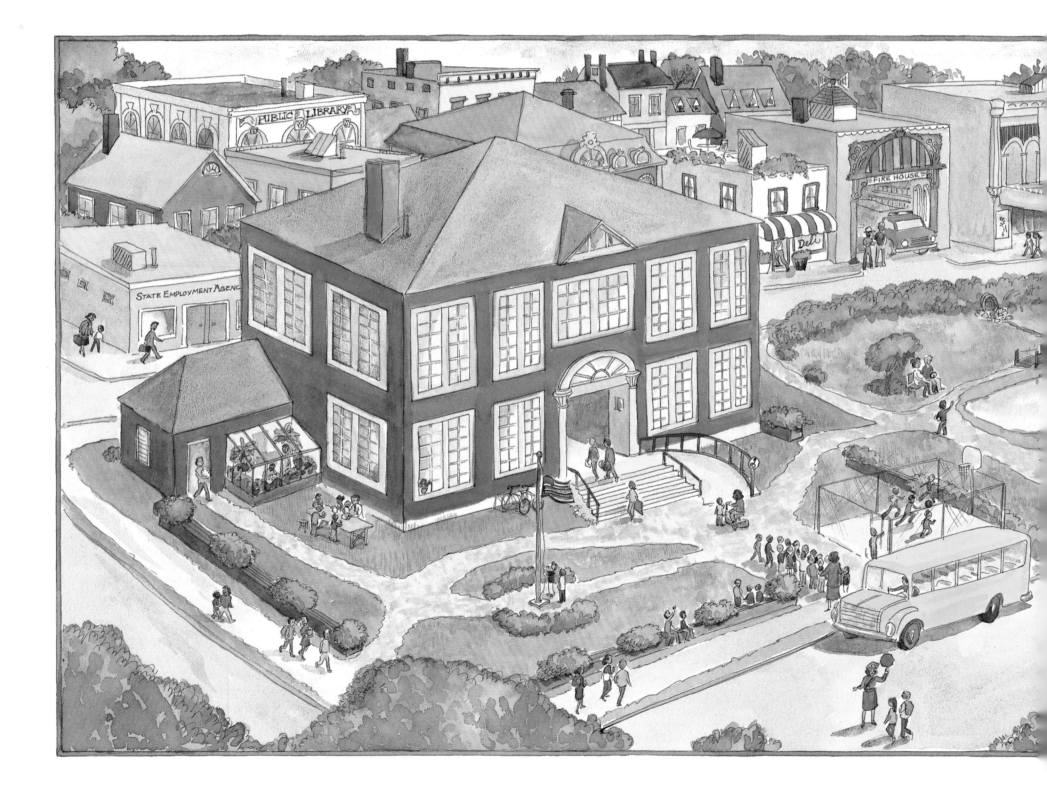

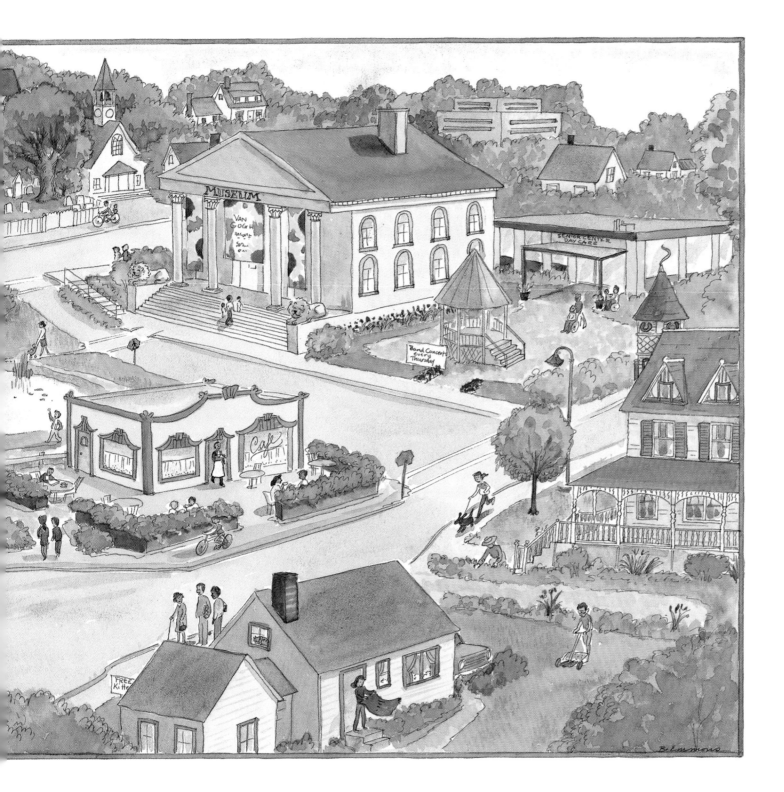

This is where I live . . .

"Where there is no vision, the people perish…"

Proverbs 29:18

Carolyn Sollman

Active in art education regionally and nationally, Carolyn Sollman is dedicated to the idea of innovative teaching and learning through the arts. With the publication of her book *Through the Cracks,* Sollman has become Project Director for the "Close the Cracks" program sponsored by the Center for Arts in the Basic Curriculum in Washington, D.C. With this position, Sollman gains a national platform from which to raise public awareness about the current problems in the schools and the ways the arts can address and solve these problems.

Sollman received her B.S. and M.A. degrees from Ball State University in Muncie, Indiana. She has taught art to elementary, middle, high school and college students. Sollman has also been an active member and leading officer in both the Art Education Association of Indiana (AEAI) and the Indiana Alliance for Arts Education. Through AEAI, Sollman initiated a cultural exchange program with Japan to explore and expand the possibilities for art education in the U.S., particularly Indiana, and Japan. Sollman's work as an art educator has led to her appointment to a number of special task forces and advisory committees, including the Indiana Department of Education Fine Arts Advisory Committee to the State Board of Education. Sollman has also been a collaborating writer for several visual art textbooks.

Besides her work as a leading educator, Sollman's drawings and paintings are widely shown and have received numerous awards. Carolyn and her husband John have three children and reside in Martinsville, Indiana.

Barbara Emmons

An active artist and illustrator, Barbara Emmons has produced work in a variety of styles and media from scratchboard to watercolor. Emmons' work has appeared in print ads, posters and numerous publications, including a recent series of over one hundred animal drawings for *Endangered Wildlife of the World.*

Barbara Emmons, born and raised in Southern Maine, received her Bachelor of Arts in Fine Arts from the Maine College of Art. She extended her formal education through her study of illustration at the Portfolio Center in Atlanta, Georgia. Emmons has won several Broderson awards for her illustrative work and has appeared in *Print* magazine. This recognition reflects both the excellence and appeal of Emmons' art.

Presently, Barbara Emmons works as full-time illustrator; her original illustrations enliven the tale of *Through the Cracks.* Emmons and her husband, cabinet-maker Don Tarr, divide their time between the couple's home in Decatur, Georgia and their native state of Maine.

Judith Paolini

As a successful graphic designer in a competitive market, Judy Paolini knows how to combine her awareness of a diverse public with her creative and technical skills. From her initial work in ad agencies to her positions as Senior Designer for Spalding Sports and Art Director for Hasbro Toys, Paolini has developed corporate identities, packaging, and corporate communications for a wide range of clients including ALCOA, Bollinger Fitness, Forster Manufacturing, Hedstrom Toys, Roadmaster Corporation, Sebago Shoes and United Technologies. Since 1990, Paolini has continued to thrive along with Thibault Paolini Design Associates, a graphic and industrial design firm specializing in consumer products.

Judy Paolini studied art at Hartford Art School and Westfield State College in Massachusetts, where she graduated *cum laude* with her Bachelor of Arts in Fine Art. Paolini's design awards are regional and national in both advertising and design; they include Ad Club awards, Champion Paper awards and the 1991 Art Education Association of Indiana's (AEAI) Friend of Art Education Award. In 1993 Paolini was featured in *Art & Design News* and she has served as a Board Member of the Portland Art Director's Club.

Paolini and her husband Jim Thibault, the industrial design partner of their business, have recently been designing consumer packaging, new product introductions and trade show exhibits. Paolini and Thibault work and live in Portland, Maine.

Laurel Smith

With interests in language and literature, Laurel Smith is an Associate Professor of English at Vincennes University in Vincennes, Indiana. Smith's enthusiasm for writing has led to her teaching classes to diverse student groups in addition to her own creative and critical writing.

A native Hoosier, Smith received her B.A. from Manchester College and her M.A. and Ph.D. from Ball State University. Besides her teaching, Smith has worked to promote live poetry, writing across the curriculum, and greater awareness for cultural diversity at V.U. Beyond Vincennes, Smith has been recognized for her professional work as a teacher and scholar: she has served as delegate to the National Institute for Staff and Organizational Development (NISOD) Conference on Academic Excellence and as board member of the Indiana College English Association.

Smith's poetry and reviews have appeared in *Arts Indiana, Concerning Poetry, Journal of Mental Imagery and Flying Island.*

Laura Sollman

As an actress, Laura Sollman has been able to bring to life important ideas and art. This achievement is particularly true for her work in the documentary *Through the Cracks/ Visions for Change,* a film that blends Sollman's performance with the ideas of educators, artists, parents, and youngsters who see a prominent role for art in the basic curriculum. Sollman's sensitive portrayal of Stella, both in the documentary and in live performances across the country, has done much to interest school personnel and governmental leaders in the values depicted in *Through the Cracks.*

Sollman's work goes beyond *Through the Cracks.* She has a B.S. in Theater Performance from Ball State University. Her credits include acting and writing for stage and film. Laura Sollman presently lives and works in Chicago.